MW00464429

Pregnant and Praying

Pregnant and Praying

Elaine Tomski

CrossLink Publishing

Copyright © 2020 Elaine Tomski

All rights reserved. No part of this publication may be reproduced, distributed or transmitted in any form or by any means, including photocopying, recording, or other electronic or mechanical methods, without the prior written permission of the publisher, except in the case of brief quotations embodied in critical reviews and certain other noncommercial uses permitted by copyright law. For permission requests, write to the publisher, addressed "Attention: Permissions Coordinator," at the address below.

CrossLink Publishing
1601 Mt. Rushmore Rd, STE 3288
Rapid City, SD 57702

Ordering Information:
Quantity sales. Special discounts are available on quantity purchases by corporations, associations, and others. For details, contact the "Special Sales Department" at the address above.

Pregnant and Praying/Tomski —1st ed.

ISBN 978-1-63357-313-0

Library of Congress Control Number: 2020934536

First edition: 10 9 8 7 6 5 4 3 2 1

All scripture quotations are taken from the Holy Bible, New Living Translation, copyright © 1996, 2004, 2007 by Tyndale House Foundation. Used by permission of Tyndale House Publishers, Inc., Carol Stream, IL 60188. All rights reserved.

Published in association with Cyle Young of C.Y.L.E. (Cyle Young Literary Elite, LLC), a literary agency."

Praise for
Pregnant and Praying

What a beautiful way to stay connected to the heavenly Father during one's pregnancy. These prayers are a gift to every woman who is expecting a little miracle.

—**Crystal Bowman**

Award-winning, bestselling author of more than 100 books including *Our Daily Bread for Kids* and *Mothers In Waiting--Healing and Hope for Those with Empty Arms.*

When I was expecting my first child, I was obsessed with every detail of his development. Pregnant and Praying combines those milestone moments with praises to our Heavenly Father. The truth is, it's never too early to begin praying for our babies, and this book will help you do just that.

—**Bethany Jett**

All-boys-momma and award-winning author of *They Call Me Mom* and *Platinum Faith*

It's an honor to share my enthusiasm for this opportunity for women to give lasting expression to their thoughts and prayers for their unborn children. I believe the results of using Pregnant and Praying will keep a mother's thoughts focused in a godly direction, encourage hope in her heart, and one day be the means of sharing a godly legacy to her family. I am thankful to recommend this book as a resource.

—**Dwight Mason**
Lead pastor of NewPointe Community Church since 1985 and author of *Only God: Change Your Story, Change the World.* NewPointe is a thriving and growing group of more than 5,000 people across six multiple locations in Eastern Ohio.

Elaine Tomski, my personal friend, a student of God's Word, and lover of Jesus prayerfully chronicles a baby's miraculous journey through pregnancy. *Pregnant and Praying* is a must-read for all expectant mothers in their loving preparation for baby's arrival.

—**Beverly Nottingham**
A former Bible Study Fellowship Teaching Leader and educator, mentor of women, wife to Mike, mother of four sons, and grandmother of thirteen.

I love Elaine's delightful, relatable details of pregnancy as, week-by-week, we anticipate the next wonder. This book is a perfect gift for the expectant mom and a great tool for those of us who serve in pregnancy centers. What a life-changing message of hope, affirmation, and peace this book gives!

—**Diane Angilella**
Volunteer and Director of Birthright of Richmond, Indiana for 35 years, and Birthright International Regional Director for Michigan and Indiana, for 20 years. Wife, mother, grandma.

For Simon Jeffrey, our family's newest miracle.

You made all the delicate, inner parts of my body
and knit me together in my mother's womb."
Psalm 139:13

Contents

Preface

Pregnancy is a miraculous journey requiring 280 days and just as many questions. How does God do it? How does he grow a new human being in the dark seclusion of our bodies?

When my babies grew inside of me, every little poke and pain caused me to either wonder or worry. The medical professionals listened briefly so they could address my questions. But God always listened for as long as I needed to speak. He alone gave my heart calm. Ultimately, I delivered a treasured boy, and twenty-two months later, a precious girl. To this day, both are miracles through and through.

You may be growing a little boy or a little girl in your womb. The following prayer starters represent both. Please use these prayers to pour out your heart to God. The empty spaces on each page invite you to journal your personal prayers. You can also create a keepsake by recording the hopes you hold dear for your child.

God wants to give you his joy and his calm. He loves to hear from you mama. He's already in love with your tiny babe, both body and soul.

Acknowledgements

With gratitude to www.thebump.com, my source for prenatal development.

Thank you, God, for little babies everywhere.

4 Weeks

Thank you, God, for what you have made. You have made everything outside of me. You have created the whole universe. You have made everything inside of me, including this little person the size of a poppy seed. My little one's height, hair color, and eye color are already programmed. I don't know these details yet, but you do, God. Please keep my little one safe and keep him growing. I trust you to help give life and growth to this precious little one behind my belly button and near to my heart.

My help comes from the Lord, who made heaven
and earth!
Psalm 121:2

5 Weeks

Oh, God. I'm sore, nauseated, and tired. I feel bloated and not so good. Although excited about this new life, I'm also somewhat afraid. Still, I thank you for this little one growing so fast in the safe, warm place inside of me. Please protect and provide for her small body as her major organs and systems are already beginning to form. Most of all, protect my baby's teeny, tiny heart.

The Lord is my shepherd; I have all that I need.
Psalm 23:1

6 Weeks

Is it possible, God, that my little one who is the size of a sweet pea is already sprouting eyes, ears, and a nose? How amazing you are to grow him so quickly inside of me. As the blood circulates from his heart through his tiny body, give my baby every little thing he needs. My baby is growing like crazy. I sometimes feel like I'm going crazy. Please help me, too. Help me deal with swinging emotions. Help my body do what is necessary to give life to my little sweet pea. Thank you for hearing me and for trusting me with this precious little person.

He does great things too marvelous to understand.
He performs countless miracles.
Job 5:9

7 Weeks

Thank you that my little one already has a heartbeat and wiggles. How do you do it, God? I am amazed that she has doubled in size since last week! Please provide for the healthy growth of my little one's rapidly growing brain cells, heart, developing kidneys, as well as her small arm and leg joints. My little one is super busy at developing, but you are never too busy to hear and answer my prayer. I am grateful to you, God.

Thank you for making me so wonderfully complex!
Your workmanship is marvelous—how well I know it.

Psalm 139:14

8 Weeks

You provide all that is needed, God. Thank you that you are fashioning taste buds for my little one who is now the size of a raspberry. Maybe raspberries will be a favorite flavor for my hungry one? I can't feel movement yet, but you can see my baby moving his arms, legs, fingers, and toes. Thank you for the growing. Please also provide me with what I need to combat nausea, hunger, and tiredness. You never grow tired or weary, God. I know I can trust you to provide.

> *Let them praise the Lord for his great love and for*
> *the wonderful things he has done for them.*
> *For he satisfies the thirsty and fills the hungry with*
> *good things.*
> Psalm 107:8–9

9 Weeks

Change is happening to my body, mostly inside it. Thank you for the one you have placed here behind my belly button. Thank you that my baby is developing more facial features. I wonder what she will look like. Whose eyes? Whose mouth? Whose little nose have you given? Speaking of change, my moods shift quickly these days. Help me to remember this is all a part of pregnancy. Help me to remember I can rest in you no matter what. Help me to be kind. Thank you that you never change, God. I can count on you.

But the Lord's plans stand firm forever; his intentions can never be shaken.
Psalm 33:11

10 Weeks

Wow! Thank you that my little one is over an inch long. Big enough to have working joints for his teeny arms to move and tiny legs to kick. Thank you that my baby's bones are forming—his fingernails and hair already visible. Unbelievable! Thank you that my little one's vital organs are fully developed and already beginning to function. Please help them work as you have precisely designed. As my body changes and grows, please help me to make healthy choices. Thank you for this amazing gift you have entrusted to me. A life this small is a huge deal. I am grateful you are a big God.

I will praise you, Lord, with all my heart; I will tell
of all the marvelous things you have done.
Psalm 9:1

11 Weeks

I feel queasy and tired, God. Baby-building is hard on my body. How I wish I could hold my little one already. But your plan takes time, and I know your way is perfect. How amazing that my baby is moving gracefully. No more webs on my little one's fingers or toes mean they are moving freely, too. Thank you for the itty-bitty tooth buds now forming. I can already imagine seeing the first tooth peeking through. I will write this special event down in the baby's book. Will the cover be pink, or will it be blue? Only you know at this point. Thank you, God, that you are wise and have a perfect plan for my precious little one. I can trust you.

"For I know the plans I have for you," says the Lord.
"They are plans for good and not for disaster, to
give you a future and a hope."
Jeremiah 29:11

12 Weeks

Since you know everything, God, how is my little plum-size cherub doing? How can it be that all of her critical systems have formed at only twelve weeks? Thank you that you know and love her even more than I do. That seems impossible, yet I know it's true. Thank you that my babe is developing reflexes. If I could poke her little body, she would move in response. Awesome! Thank you that her tiny fingers are opening, and her little toes are curling. As you knit my baby together, please protect her little brain as it develops. Form it perfectly knowing, all-knowing God. My belly is getting notice-ably more prominent. Seeing my baby bump reminds me how thankful I am for the precious life rapidly growing within me.

O Lord, you have examined my heart and know
everything about me.
Psalm 139:1

13 Weeks

You alone are God. Unique and holy, no one is like you. I thank you that you create each person uniquely. Thank you that my little peach has his own teeny, tiny fingerprints already! There is no other child like him. I can't wait to hear his voice, even his cries. Thank you for fashioning his vocal cords and teeth in this thirteenth week and for tucking his intestines into his little tummy. I praise you that my first trimester is coming to an end, bringing with it less fatigue and nausea. Thank you for being my strength when I have none. I look forward to feeling better and stronger in the weeks to come.

God is our refuge and strength, always ready to help
in times of trouble.
Psalm 46:1

14 Weeks

Oh, God, you are good. You have brought us through this first trimester. You are giving me more energy and more of an appetite to enjoy eating again. Thank you! My babe is the size of a lemon but not a bit sour. She is sweetly sucking her thumb and wiggling her toes. Please protect her little body. Thank you that her liver and spleen are doing their jobs and that her kidneys are working to make urine. I better stock up on diapers! How good you are to make way for my little tot to be toasty warm. You have given her peach fuzz hair all over her body just for that reason. I am amazed by the good and perfect plan you have for my baby. Thank you, thank you, thank you!

Give thanks to the Lord, for he is good! His faithful love endures forever.
Psalm 136:1

15 Weeks

You see everything, God. You notice my little one squirming about behind my belly button. It's going to be fun when I can feel the squirms. Thank you that all of my little cherub's joints are moving. How exciting that his legs are growing longer. Thank you that he is nearly four inches tall. Please soothe him when he has the hiccups. You will have to hold him in your capable hands until I can. I trust you, all-seeing and all-loving God.

You watched me as I was being formed in utter
seclusion, as I was woven together in the dark
of the womb.
Psalm 139:15

16 Weeks

Gracious God, thank you that I get to be a mama. I think I'm beginning to feel my bundle of joy move! That makes her life seem even more real to me. To think that you are forming the tiniest little bones in her ears and she can begin to hear my voice. It is incredible I can talk and sing to her, knowing that she hears me! Thank you for fashioning strands of hair on her head and for growing her eyebrows and lashes. Since she is now developing taste buds, I wonder what she thinks of her little thumb. Does it taste good? What will her favorite foods be? Thank you for what you have made. It is a gift from you that she lives and moves, for you are the Author of Life.

Children are a gift from the Lord; they are a reward
from him.
Psalm 127:3

17 Weeks

You are in the business of growing, God. Thank you that my little one is growing bigger each day, adding on some muscle and some fat. Grow him stronger as his cartilage turns to bone. Even his umbilical cord is growing thicker. Thank you for your perfect provision of nourishment from my body to his so that growth can happen. Please protect this process of feeding into his belly button. My body size is also increasing, which both excites and frightens me. Please help me be the healthiest mama I can be. Show me the way. My heart grows more thankful to you every day.

I know the Lord is always with me. I will not be
shaken, for he is right beside me.
Psalm 16:8

18 Weeks

Thank you, God, for my little sweet potato–size baby. She is growing rapidly and staying busy. Thank you that she is yawning, hiccupping, sucking, swallowing, twisting, rolling, punching, and kicking. No wonder I am hungry! She needs much fuel for her growth and activities, and amazingly she gets it all from me. Thank you for protecting us both. You faithfully give us what we need and more. And even though you are busy with all of creation, you still take time to listen, time to whisper into our hearts, big and small.

The eyes of all look to you in hope; you give them
their food as they need it.
Psalm 145:15

19 Weeks

Thank you for your perfect design. You are developing a protective coating all over my little one's six inches of body. Please protect his brain as his nerve cells develop into five senses. Another perfect design from you! My bambino will learn much from all he will taste, hear, see, smell, and feel. Thank you, good and gracious God. Help me be patient as you continue to grow this child of mine, this child of yours.

"Let the children come to me. Don't stop them!
For the Kingdom of God belongs to those who are like these
children."

Mark 10:14

20 Weeks

I can't believe we are halfway there, God, halfway to making a uniquely perfect individual. I am so blessed to be a part of your creative plan for this precious one. Thank you that she now has little taste buds. I wonder how that amniotic fluid she is swallowing tastes. It sounds yucky to me, but she must like it. I can't wait until she tastes applesauce and bananas. Help me, God, in the waiting, to rest in you.

Taste and see that the Lord is good. Oh, the joys of those who take refuge in him!
Psalm 34:8

21 Weeks

When I think of my little treasure, I realize how incomprehensible you are, God. It's beyond my understanding that if the baby in my womb is a girl, she already has six million eggs in her ovaries, enough for her lifetime. That's unbelievable! And yet I believe you can do it. You can take care of such details every day forever. You are truly awesome! Also surprising is the fact that my little one has a digestive system already preparing the black gooey stuff for her first dirty diaper. There is no mistake that you have a plan for this little cherub's life.

Great is the Lord! He is most worthy of praise! No
one can measure his greatness.
Psalm 145:3

22 Weeks

Thank you, God, for reminding me every time I feel my babe move how you are growing him inside me. I appreciate the times when he is still, too. Thank you that he is sleeping in cycles, twelve to fourteen hours per day. So much growing must make my little one tired. I love that his little face looks more like a newborn, with eyes and lips more developed. You are kind and gracious. Thank you for loving us both.

For your unfailing love is as high as the heavens.
Your faithfulness reaches to the clouds.
Psalm 57:10

23 Weeks

All-powerful God, it is incredible what you can build in just twenty-three weeks! Thank you that my little bundle has a fully formed face. She must be a cutie! Please continue to fatten her little cheeks. The small details matter to you, even down to the little nipples she is now forming. Thank you that she is listening, that she can hear my heartbeat, my voice, and the loud sounds coming from outside of me. I can say, "I love you," and she hears me! Thank you, God, for listening to me, too. I feel loved.

Praise God, who did not ignore my prayer or with-
draw his unfailing love from me.
Psalm 66:20

24 Weeks

From the size of a poppy seed to twelve inches of a human being in just twenty-four weeks—what an amazing creator you are! Thank you, God, for growing my little babe. Thank you that he is getting closer and closer to being ready to survive outside my womb. Thanks, too, that his once see-through skin is getting thicker with a new pink glow. If I could, I would pinch his little cheeks before landing a kiss on his tiny nose right now. I am not feeling patient. I am becoming more and more uncomfortable. But I'm thankful you are an always patient God.

> *"I am the Lord, the God of all the peoples of the*
> *world. Is anything too hard for me?"*
> Jeremiah 32:27

25 Weeks

Thank you, all-knowing God, for making my young one in your image. Thank you that she also knows some things. She already knows which way is up and which way is down. Oh, there is so much for her to learn and understand. I thank you that you are not only forming her body but also her mind and spirit. I am grateful that she is growing fat on her body and more hair on her head. Keep her safe in your care, loving God.

For we are God's masterpiece. He has created us
anew in Christ Jesus, so we can do the good things
he planned for us long ago.
Ephesians 2:10

26 Weeks

You are an ever-faithful God. Thank you for your faithfulness to my little one. Thank you that much is happening in his development. Thank you for his forming eyes and that he will soon start to open those eyes. Who will be able to resist when he flashes his little eyelashes? You are self-sufficient, but my little one is still inside and dependent on me. Thank you that he is soaking up my antibodies so that his immune system is ready when he makes it to the outside. Thanks too for getting him prepared to breathe, already taking breaths of amniotic fluid. Practice, practice, practice. Thank you for developing his senses, features, and talents. I am grateful that you are in charge of every detail.

He will cover you with his feathers. He will shelter
you with his wings.
His faithful promises are your armor and
protection.
Psalm 91:4

27 Weeks

Ever-wise God, thank you for making my child in your image, with the ability to know and to reason. Thank you that he has brain activity and that his brain is becoming more and more complex. Please help my child to be wise, full of knowledge, and truth. Thank you that his lungs are rapidly developing. I pray that he is breathing you into his very soul, the soul you gave him because you are making him in your image. You, being eternal, make each one of us with a desire and ability for eternity. You are beyond understanding, God, and I am beyond grateful for what you are creating behind my belly button.

For your kingdom is an everlasting kingdom. You
rule throughout all generations.
The Lord always keeps his promises; he is gracious in all he does.

Psalm 145:13

28 Weeks

Thank you, God, that we are in the homestretch. Third-trimester, here we are. Woo-hoo! Thank you that you have provided everything needed for my little one to grow bigger, stronger, and smarter. Thank you for smoothing out the wrinkles in her skin as she continues to put on more fat. Thank you that her lungs have developed enough that she can survive even if born now. Thank you, too, for providing the nourishment she will need at birth—the colostrum already waiting in my breasts. You are a fantastic provider, God.

"For the Lord your God is with you wherever you go."
Joshua 1:9

29 Weeks

God, your plan is for growing. Thank you for increasing my little one to sixteen whole inches of length and three pounds of weight. No wonder I'm feeling his movements as he becomes more crowded behind my belly button. To think that he could triple in size before birth is mind-boggling and belly-boggling! Thank you that he is forming fat deposits under his skin, increasing his energy. How amazing it is that you are recreating my body to accommodate my growing babe. Patient, kind, unchanging God, help me to be loving and patient in the midst of all the changes happening to me and in me.

"Be still, and know that I am God!"
Psalm 46:10

30 Weeks

Thank you, God. You have protected my little one for the first thirty weeks of her life. Thank you that her skin is getting smoother and her brain is getting more wrinkly—preparing her brain tissue for tons of knowledge and memory. Thank you that she is strong enough to grasp things with her tiny little hands. Your creation within me is impressive. I am grateful you protect us— body, mind, and spirit.

*But let all who take refuge in you rejoice; let them
sing joyful praises forever.
Spread your protection over them, that all who love
your name may be filled with joy.*
Psalm 5:11

31 Weeks

O h God, you have breathed life into this sweet babe of mine. Thank you for giving him life and for developing his five senses. I wonder what he can already see, hear, smell, taste, and feel. It's fun to imagine what he is experiencing already. How amazing that the tiny iris in his eyes can react to light. I think of his home behind my belly button as a dark place, but he can see the light coming in. You know everything, God. Please protect my baby's intellect as his brain and nerves continue to develop. Make him smart, but most of all, cause him to know you. Will you help me, too? It's getting harder for me to move and breathe. Help me to know your presence. Keep breathing your life into me and my precious little one as I trust in you.

Let everything that breathes sing praises to
the Lord!
Psalm 150:6

32 Weeks

Thank you, God, that I can always talk to you. It is beautiful to me that you like to hear what I have to say. Is it possible my bundle of joy is turning upside down and getting ready for her descent? Eight weeks left seems like a long way to go, but I'm not ready yet at the same time. Help me to be like you, patient and wise. Protect my growing baby as she gets more cramped inside me. Thank you that even though I am short of breath, she is getting plenty of air. Thank you for loving my child and me so much.

Your unfailing love, O Lord, is as vast as the
heavens; your faithfulness reaches beyond
the clouds.
Psalm 36:5

33 Weeks

Oh, God, can it be true that you will grow my little guy up to a full inch in length this week? How incredible you are! Thank you that my cutie pie now keeps his eyes open while awake. Thank you that he can coordinate breathing with sucking and with swallowing. You always take care of every detail. Make my little guy stronger as you harden his bones. And thanks for continuing to make him smarter even as it seems that I am becoming dumber. I know it's just pregnancy brain, but sometimes I wonder if I will be bright again. Or cool again. Help me remember this is all part of your incredible plan.

Everything he does reveals his glory and majes-
ty. His righteousness never fails.
He causes us to remember his wonderful
works. How gracious and merciful is our Lord!
Psalm 111:3–4

34 Weeks

Loving God, I need your help. Help me to be more like you, kind and good. My babe is listening, and I want her always to hear loving words coming from my mouth. Thank you that she is reacting to simple songs, too. I love that she can listen to me singing to her. I love that she will even recognize those songs once she is born! But here is what I don't like to consider. Is my baby urinating a whole pint per day? Yuck! Where is that going? Only you can take care of such yucky things in an entirely perfect way. I'd better get the diapers ready. Provider God, help me supply everything needed for this one you are growing inside.

Lord, don't hold back your tender mercies from me.
Let your unfailing love and faithfulness always
protect me.
Psalm 40:11

35 Weeks

Thank you, God, that my child is growing, growing, growing! Now the size of a coconut, no wonder he is pressing on everything inside of me. When he kicks my bladder, I'm grateful he can hear me squeal with his fully developed hearing. If my little one is a boy, thank you that even his tiny testes have likely descended. You get him ready in so many ways! Both my little one and I are rapidly changing. I am comforted by the fact that you, God, never change. You are entirely complete at all times. It gives me comfort, especially during all the change happening in my life, that I can count on you.

Whatever is good and perfect is a gift coming down to us from God our Father, who created all the lights in the heavens. He never changes or casts a shifting shadow.
James 1:17

36 Weeks

Thank you, God, that my little honey has grown as big as a honeydew melon! You gave the breath of life to me so many years ago, and now you are giving it to her. Thank you that she is getting closer and closer to being able to breathe on her own. You are preparing her to suckle with rigid gums. You are smoothing out her skin. You are making sure her liver, kidneys, circulation, and immune systems are in working order. Only four weeks to go! I am grateful. Keep her growing safe and sure. Breath of heaven, breathe your peace into her very soul.

> *"I knew you before I formed you in your mother's womb.*
> *Before you were born I set you apart."*
> Jeremiah 1:5

37 Weeks

Thank you for being the God of order. Everything in your creation has a plan and a purpose. Thank you that you are getting everything in order inside my little one. He is becoming skilled as he practices inhaling and exhaling. He is sucking, gripping, and blinking. He is even getting ready for his very first poop. Thank you for helping me prepare for his arrival by giving me a nesting instinct and increasing my energy. Help me be patient, as my babe continues to grow healthier and stronger. You have ordered our days; help me to rest in that truth.

You saw me before I was born. Every day of my life
was recorded in your book.
Every moment was laid out before a single day had
passed.
Psalm 139:16

38 Weeks

Thank you for my sweet little pumpkin, God. How is it that you make life begin as the size of a poppy seed and grow into a six-to-nine-pound, pumpkin-size baby? You are incomprehensible! Who can understand how amazing you are? I know you can help me in these final weeks of pregnancy. Help me as my plumping one kicks every nerve, even ones I never knew I had. Help me recognize the signs of labor as they come. Thank you that you are perfecting my little one as she grows hair and sheds the gooey covering on her skin. Thank you for taking care of every detail. Help me to remember that because you are amazing, I can relax.

Yet God has made everything beautiful for its own time. He has planted eternity in the human heart, but even so, people cannot see the whole scope of God's work from beginning to end.
Ecclesiastes 3:11

39 Weeks

Thank you, God, for allowing me to notice little knees, elbows, head, and feet poking out my abdomen. I can't wait to see and snuggle my bundle of joy. You are a patient God. I don't feel a bit patient right now. Can we get this baby out of me soon? You are also all-knowing and wise. I am thankful you know the right moment for my baby's birth. Thank you that he is still growing, moving, and getting smarter by the week. Give me your wisdom and your strength as I wait.

You go before me and follow me. You place your
hand of blessing on my head.
Such knowledge is too wonderful for me, too great
for me to understand!
Psalm 139:5–6

40 Weeks

Eternal God, I thank you for what you have created behind my belly button and near to my heart. This pregnancy has seemed like an eternity. Thank you that it is finally nearing completion, and a new human being will soon emerge. I am grateful for the love and care you have shown my precious babe and me over these forty weeks. Thank you for every last detail of her growth. Thank you that she is still growing hair and nails. Thank you that you are perfecting her ability to breathe. I am anxious about her birth. Help me to breathe! Help me experience your presence and your peace during the birthing process. Most of all, God, I pray my little one will know you have created her for eternity. Everyone spends eternity somewhere. Make her aware and open to the perfect way you want to save her so that one day when she walks away from you, as we all do, she will choose to come back to you through your Son, Jesus. You are forever gracious, and I am eternally grateful.

*Surely your goodness and unfailing love will pursue
me all the days of my life,
and I will live in the house of the Lord forever.*
Psalm 23:6

Printed in the United States
By Bookmasters